JAMES CHRISTENSEN

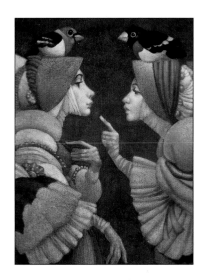
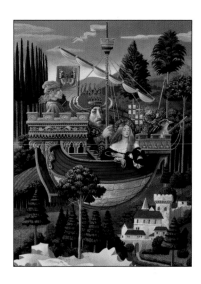
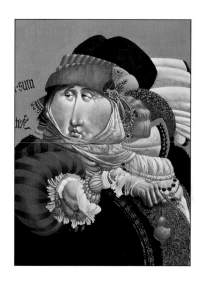

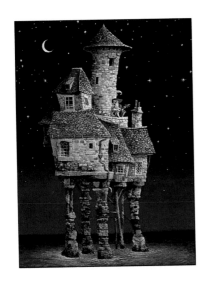 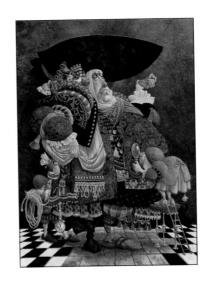 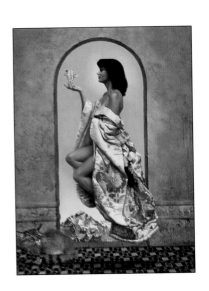

FOREMOST FANTASY ARTIST

JAMES CHRISTENSEN

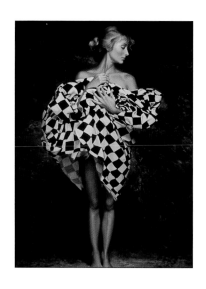
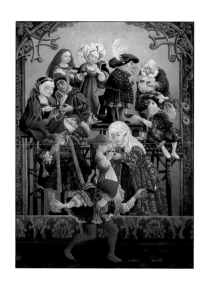
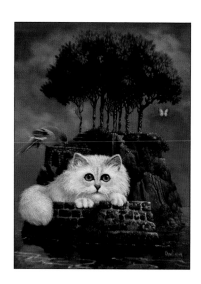

NEW CENTURY ARTISTS SERIES

A SHOWCASE OF CONTEMPORARY MASTERS

THE GREENWICH WORKSHOP PRESS

A GREENWICH WORKSHOP PRESS BOOK

Published by The Greenwich Workshop Press, One Greenwich Place, P.O. Box 875, Shelton, CT 06484. (203) 925-0131 or (800) 243-4246.

LIBRARY OF CONGRESS CATALOGING-IN-PUBLICATION DATA
Christensen, James, 1942-
 James Christensen: foremost fantasy artist.
 p. cm. –(New century artists series)
 Includes index.
 ISBN 0-86713-073-3 (alk. paper)
 1. Christensen, James, 1942–Catalogs. 2. Fantasy in art–Catalogs.
 I. Title. II. Series.

ND237.C4943 A4 2001
759.13–dc21 2001040299

The author and publisher have made every effort to secure proper copyright information. In the event of inadvertent error, the publisher will be happy to make corrections in subsequent printings.

Limited edition prints and canvas reproductions of James C. Christensen's paintings are available exclusively through The Greenwich Workshop, Inc. and its 1200 dealers in North America. Collectors interested in obtaining information on available releases and the location of their nearest dealer are requested to visit our website at *www.greenwichworkshop.com* or to write or call the publisher at the address above.

Front Cover: *The Burden of the Responsible Man*

Book Design by Pete Landa
Printed in Italy by Amilcare Pizzi
First Printing 2001
1 2 3 4 5 04 03 02 01

INTRODUCTION

I've been looking at James Christensen's art for about fifteen years and the thing that I still find most remarkable is that I've never run out of new things to see. I can't recall exactly when I first saw his work *The Burden of the Responsible Man,* but I know I was a young guy, unmarried, just gearing up for a career. I chuckled when I saw the funny little man. I had a job so I understood the carrot hanging in front of his nose. I thought the hedgehog with a handle was a hoot.

Marriage, a couple of kids and lots of life and business complications later, I still chuckle, but it's a wry chuckle. I understand more of the *Responsible Man* because I can see him mirror facets of my own life.

And that's what Jim's art is all about. His paintings are about his life and his observations. He muses, wonders, questions and gives free rein to his whimsical humor. But the process is never quite finished because you, the viewer, bring your own special life experiences along for the ride. Jim's art is both a connection between human minds and a point of departure for your imagination and mine.

As a species, we've always drawn upon our imagination to bring forth ideas of things unseen. From the bird-headed figures painted by prehistoric peoples on cave walls to Botticelli's angels to the extraordinary visions of hell created by Hieronymus Bosch, art was a way to give the invisible religious realm a presence in the visual world.

But the genre we've come to call "fantasy" is less concerned with portraying belief systems than giving local habitation to the "otherwhere" conceived within the artist's imagination. Its most likely roots are the English fairy painters of the 1800s. These artists saw first hand the increasing mechanization of life during the industrial revolution. The art of fantasy and imagination was a response to a world in thrall with numbers and production where human workers became mere cogs in a great machine.

World War I with its millions of casualties led to a darker vision with a fatalistic worldview. Fantasy became phantasmagoria. But the world-building of fantasists didn't entirely disappear, they merely went underground. During the thirties and forties, fantasy hid out as illustrations and book covers among the sword and sorcery classics of pulp fiction and, somewhat later, the growing genre of science fiction.

Fantasy art reemerged after the United States discovered the works of J.R.R. Tolkien, author of *The Lord of the Rings* trilogy. Tolkien, a classics professor from Britain, drew upon his scholarship in classical literature to create a work that was both fantasy and literary *tour de force.*

As a young artist with an education in classical art, James Christensen was at the forefront of the reflowering of fantasy as a fine art, the way Tolkien wedded fantasy and literature. Jim combines lifelong scholarship and technical expertise with lively, thoughtful content. The result is a lifetime of works that can be viewed on many levels, the way a rosebud opens to reveal the individual petals of a rose. Or maybe he's allowing us a chance to peel the cosmic onion.

His efforts have helped to pave the way for a new generation of fantasy artists, people like Scott Gustafson and James Gurney. He has also opened a door for many of us, whether trained or not, to feel not just comfortable, but that we are correct in drawing meaning from a work of art as it relates to our own lives. That's why I keep looking at the *Responsible Man.* I know there's always something different to discover. Maybe it helps me know myself a little better. Maybe I just enjoy having company on the road.

—SCOTT USHER,
Publisher, The Greenwich Workshop

SOMETIMES THE SPIRIT TOUCHES US THROUGH OUR WEAKNESSES

The Latin *post nubila phoebus*, translates as "after clouds, sun." It's something like our saying that every cloud has a silver lining. I think that we often grow through adversity. No one wants trials and ordeals, and yet, having passed through the darkness, we often experience great spiritual illumination and feel the most connected with our maker.

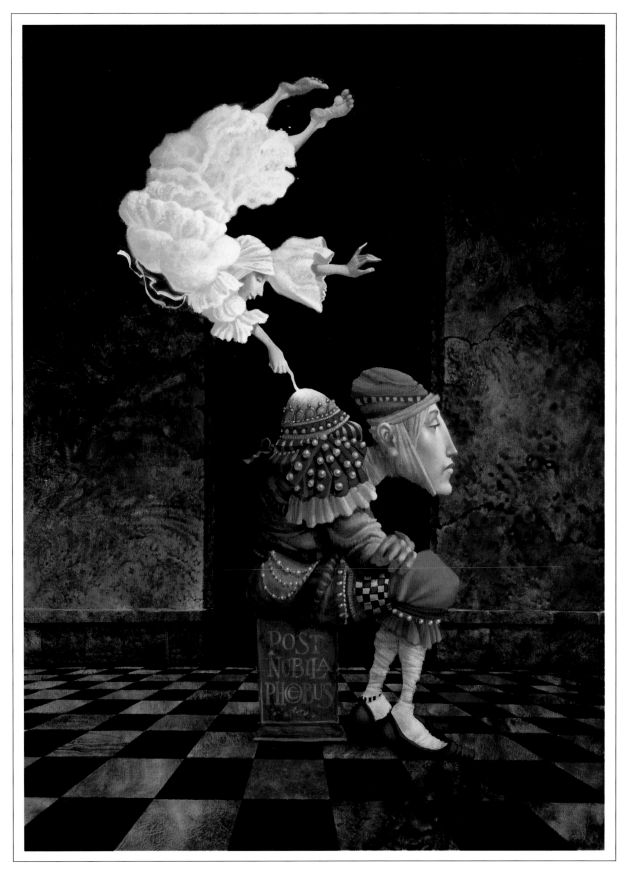

SUPERSTITIONS

I don't consider myself a superstitious person, but, knock on wood, I've never had to deal with a lot of the problems these characters do. Their town is built over the ocean on crumbling pillars, so they can't afford to do anything to incur bad luck.

Our own houses may not be built on sand or stilts, but our life in the modern day, in it's own way, is nearly as precarious as this one. They get typhoons and tsunamis and we get power spikes which ruin our RAMs and ROMs.

Life *is* uncertain. Who hasn't worried about walking under ladders or seeing a black cat cross our path? It is fun to see to what extremes we will go, as a human family, to avoid ill fortune. Best of luck, everyone!

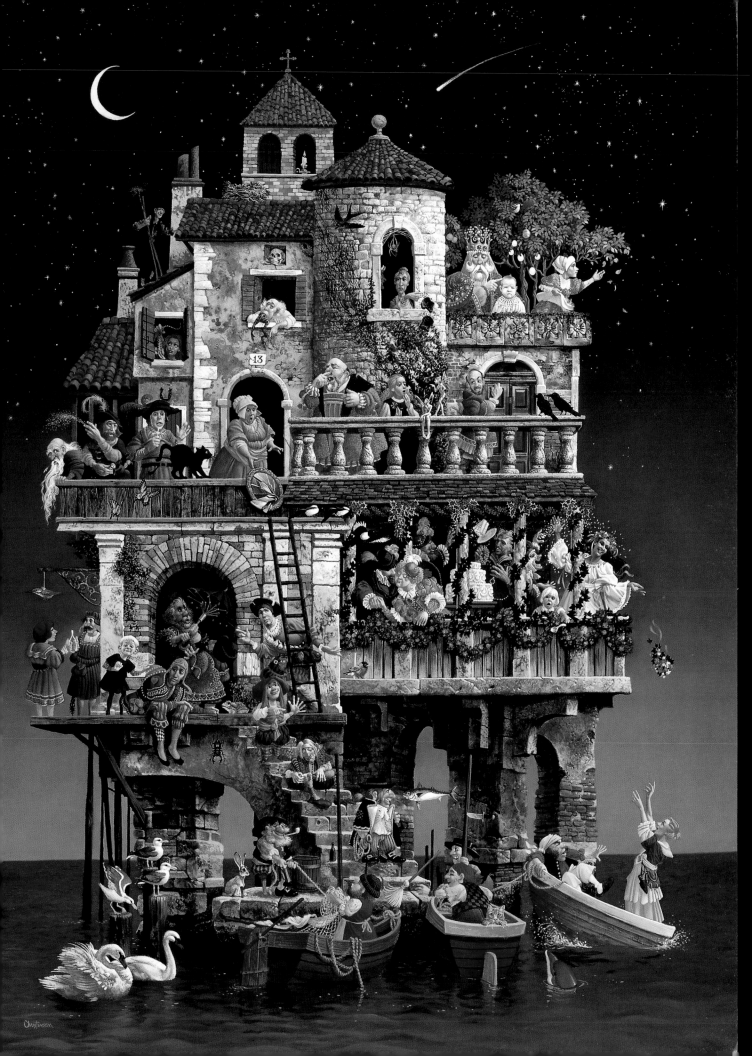

THE BASSOONIST

The Bassoonist combines my love of music and ornate costumes. If you look closely, you'll see that this is not your everyday bassoon and the bassoonist is not ordinary, either. Note how our hero has adapted: he has eleven fingers...

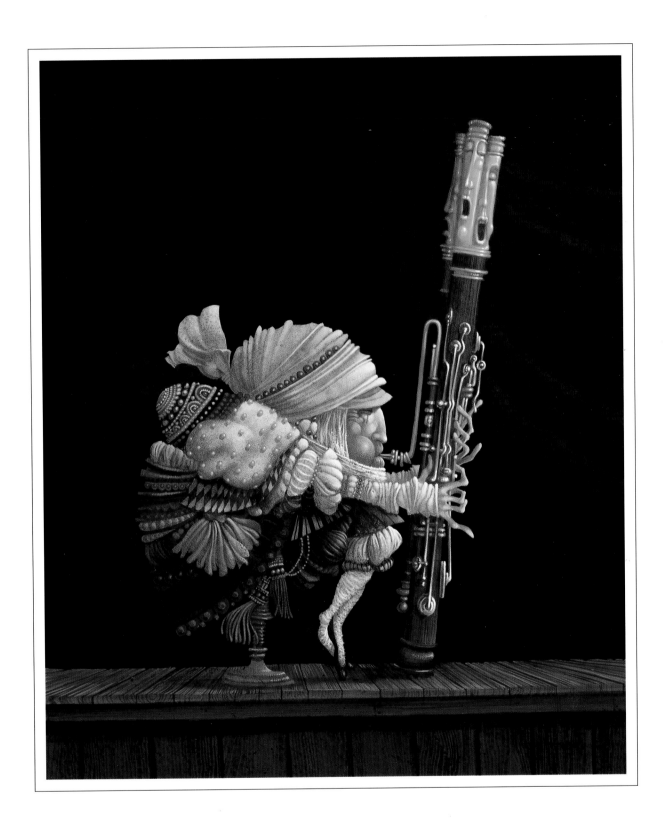

FISH IN A TOUCAN MASK

This is one of my mountebank paintings—two others, closely related, are *The Great Garibaldi* and *Levi Levitates the Stone Fish*—and I've done a few more paintings based on this idea of mediocre entertainers with one-trick magic acts. The performers are extravagantly attired, with all the distracting trappings of authority and professionalism, but the acts are fairly lame.

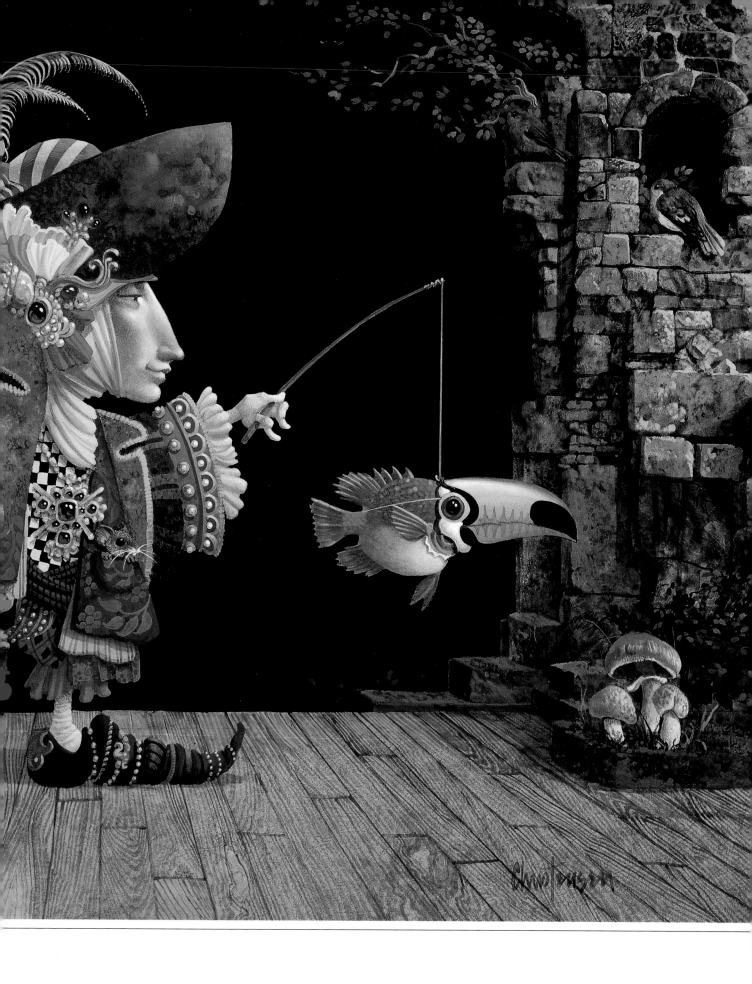

VISITATION/ PREOCCUPATION

This isn't necessarily a forboding piece. It's more about *paying attention.* The angel says, "I am dead" and the man replies, "How do you like my new clothes?" There's a failure of communication here. This guy isn't listening. What if we are so self-preoccupied that we don't recognize an angelic visitor?

Ornate and excessive clothing is one of my favorite symbols to convey our sense of self-importance. There are layers of meaning here, like the fruit he's holding, which looks a little squishy. It could be a memento mori, or reminder of his mortality.

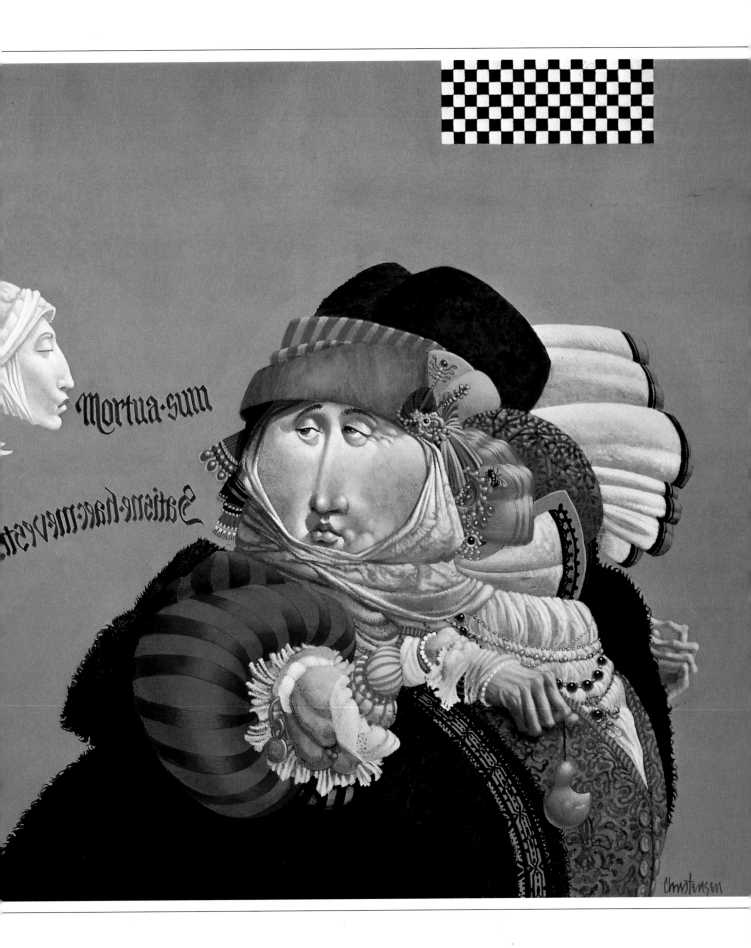

EVEN AS HE STOPPED WOBBLING, WENDALL REALIZED HE HAD A DILEMMA

Perhaps we don't recognize how external trappings both encumber us and give us a false sense of importance and security. When our focus is on appearances, what happens when we hit a bump in our lives? As long as everything goes smoothly, we're okay, but one little push leaves us like Wendall. Material possessions don't give us the strength to get back on our feet and keep going.

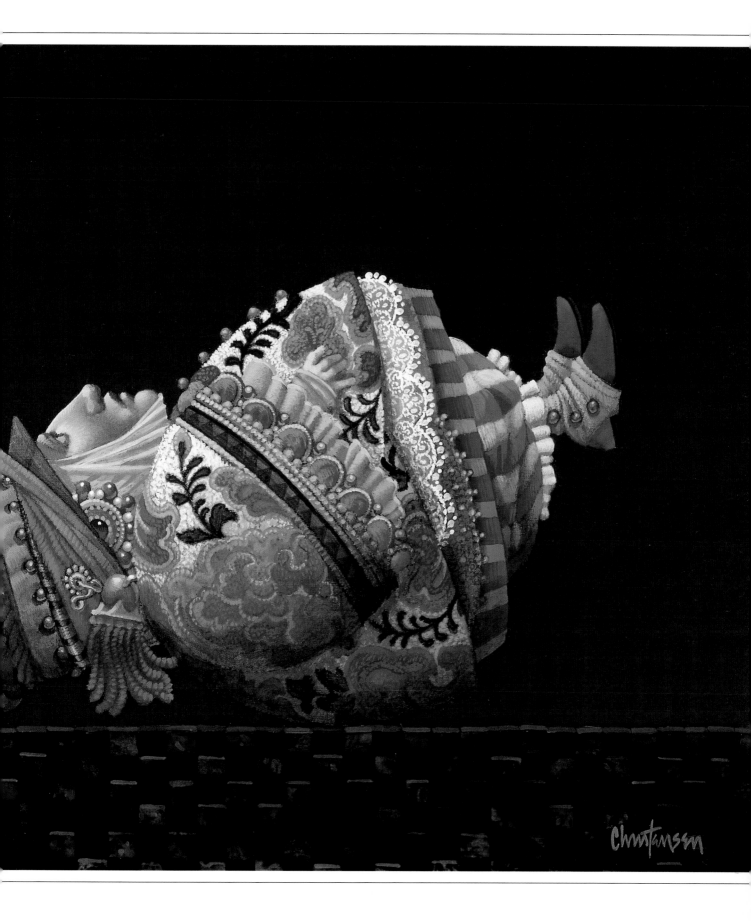

SNOW ANGEL

In 2000, eight artists were sponsored by the St. George Art Museum to spend one week on location sketching and painting Snow Canyon, Utah. The resulting artwork, inspired by this geologically marvelous desert canyon, was later exhibited at the museum.

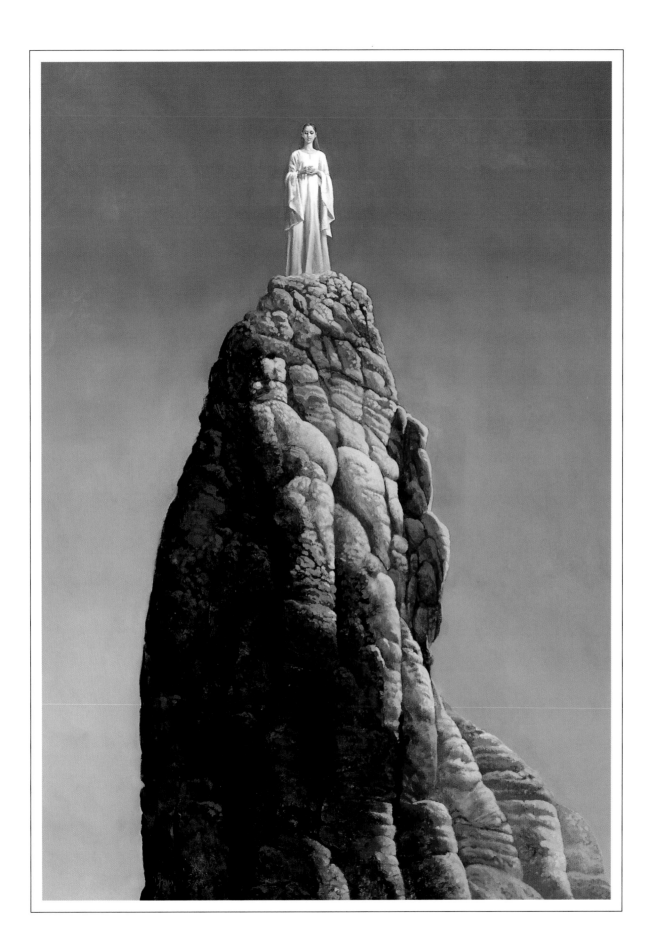

GIRL IN THE GOLDEN KIMONO

This early painting was a commissioned portrait for the woman shown here. I included things important in her life…the mountains, the cat, and the beautiful silk kimono. This painting also includes one of the earliest representations of the floating fish.

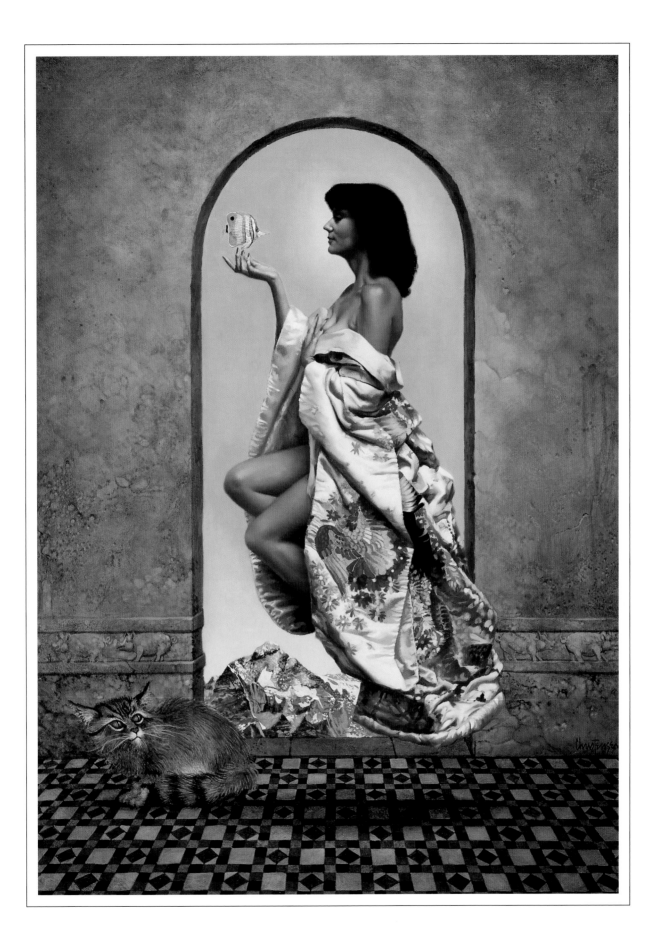

COURT OF THE FAERIES

This image was always meant to be a highlight of my book *Voyage of the Basset*. As I immersed myself in the paintings for the book over the course of three years, I would think about the Court while planning to save it for last. After the final piece of *Basset* art was done, I dedicated myself to creating this sumptuous fantasy environment with its nearly one hundred inhabitants.

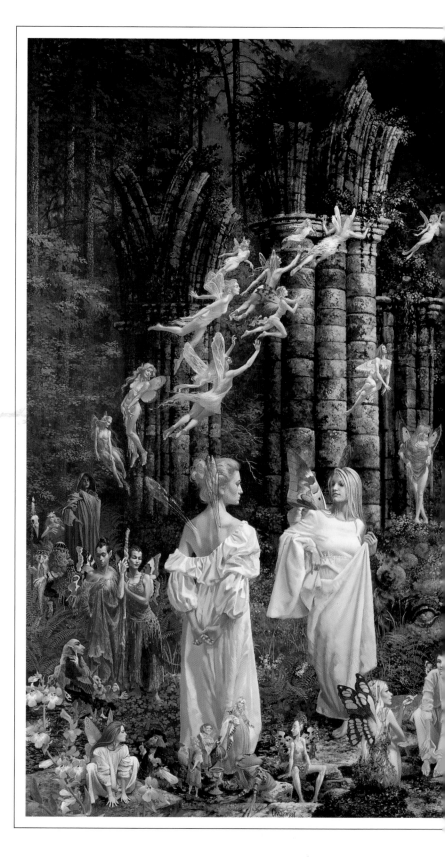

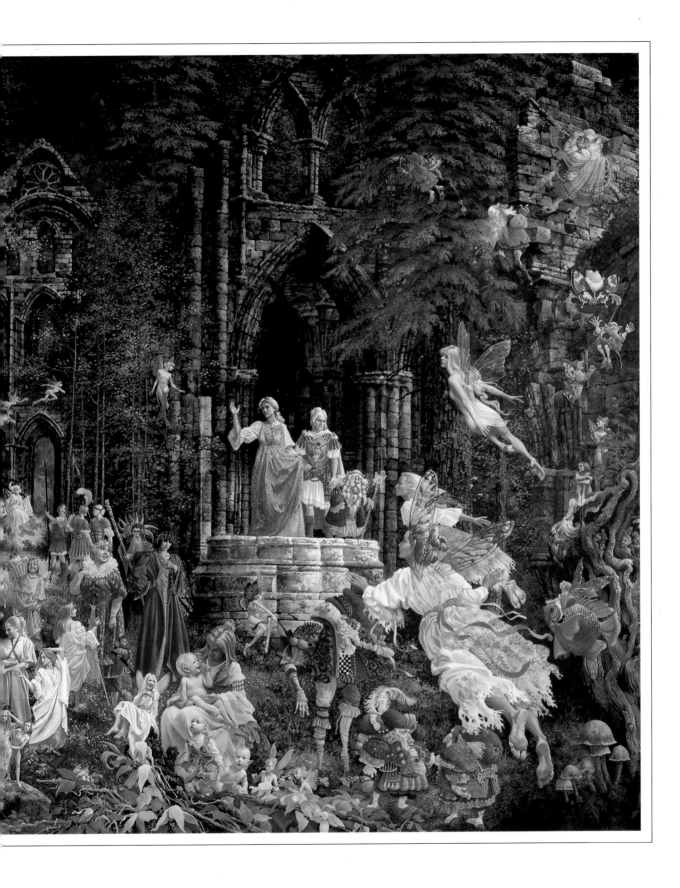

ALL HONORABLE MEN

In Shakespeare's play *Julius Caesar*, Mark Antony sarcastically refers to Brutus and the other assassins as "honorable men." This made me stop to think. Many officious, self-confident bureaucrats consider themselves "honorable" men and their ponderous garb and official bearing help support this self-deceit. (Does the suit on a bird make it an "honorable bird?")

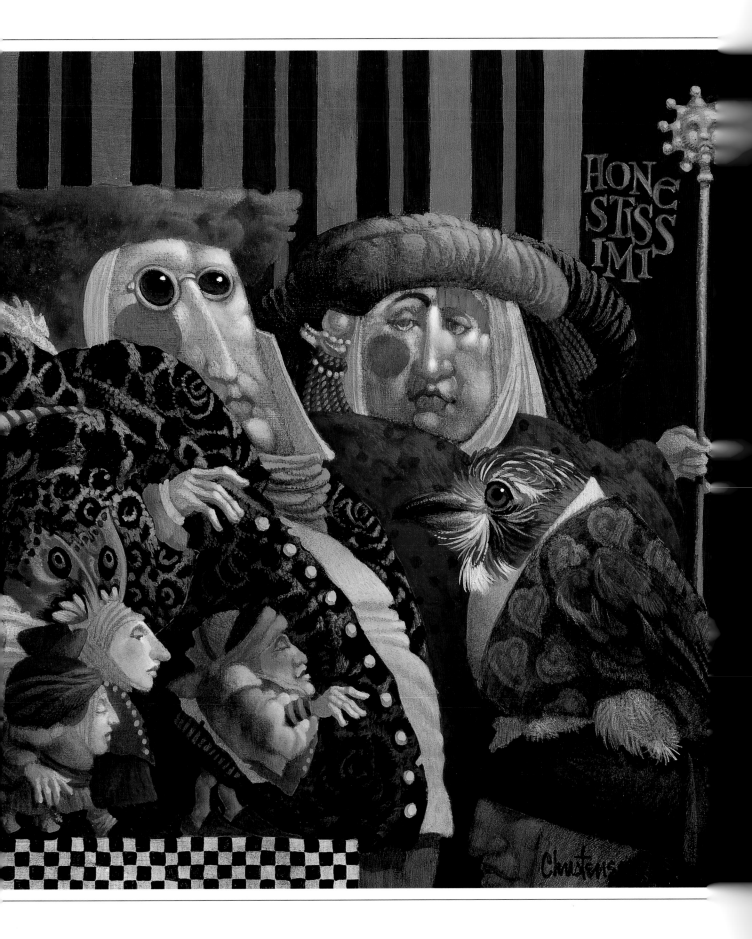

THE EMPEROR OF CONSTANTINOPLE AND VANITY ON A PLEASURE CRUISE ACROSS A QUATTROCENTO LANDSCAPE

Perhaps this would be easiest to describe as a montage *of* art, *from* art. I saw a painting of *Vanity* as a beautiful red-haired woman with a mirror and decided to use her as an element in this work of art. There's some art from the Renaissance and from the illuminated manuscripts here, as well. The real challenge was assembling the disparate elements and getting them to work together as a whole.

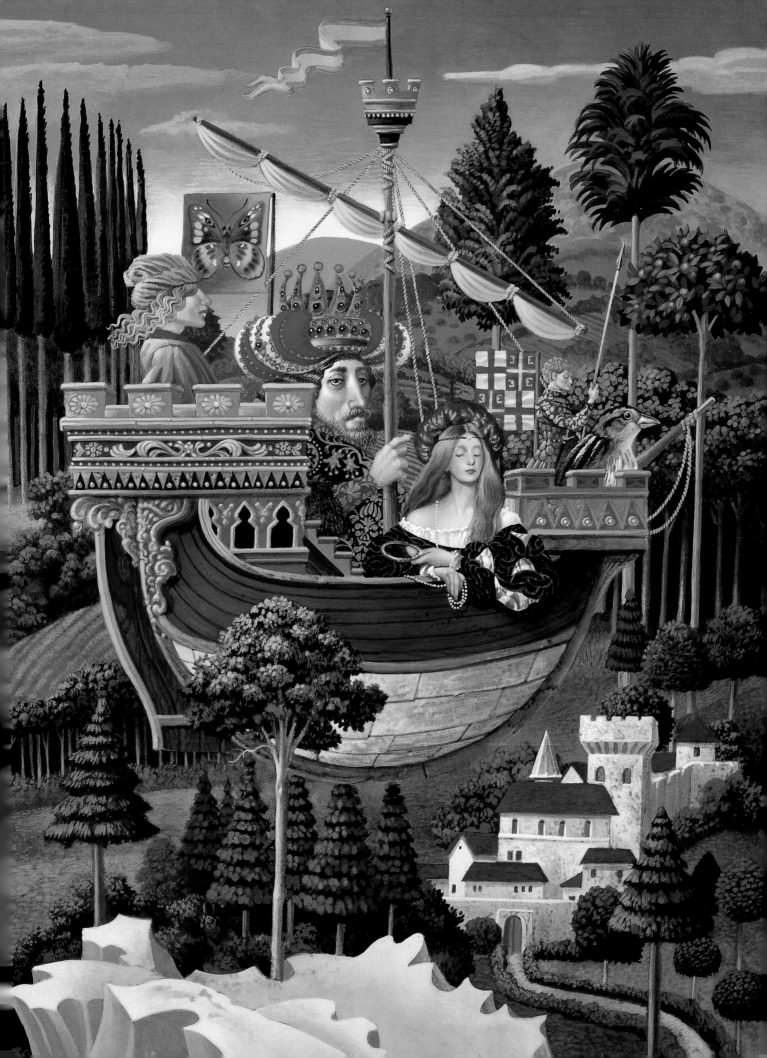

FERNANDO THE FAT FAIRY

This is a very large, loose oil painting through which I explored paint quality and texture. It was created for an exhibition at Brigham Young University.

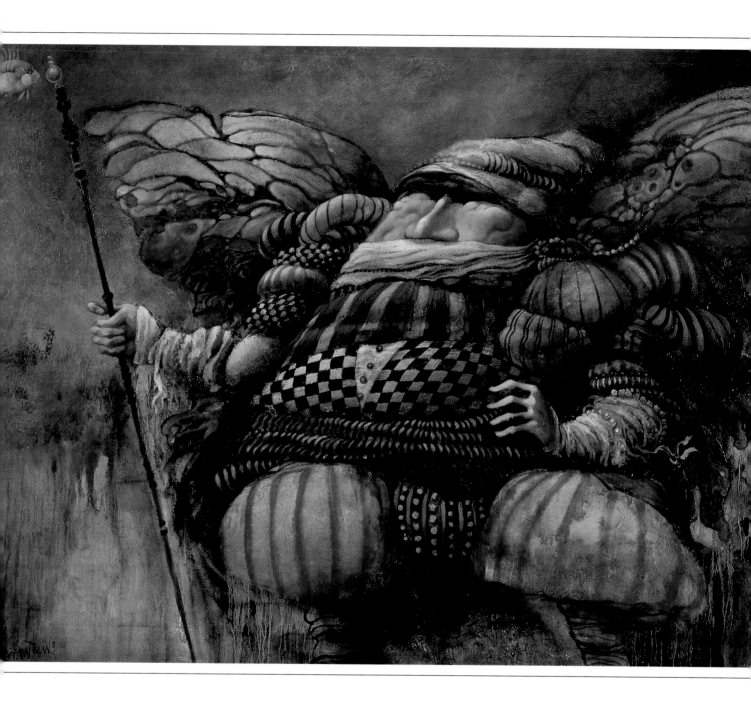

NIGHT MUSIC

I'm inspired by the architecture, people and scenery of Europe. During a recent trip, I spent the day looking at Spanish architecture and the evening dining on a Mediterranean beach. At midnight, I went for a swim. It was magical. For just a moment, I felt like I was the only guy in the universe. When I got home I painted *Night Music* to capture the intimacy of the moment. The stone house perched on stilts in the ocean represents the precariousness of those fleeting magical moments.

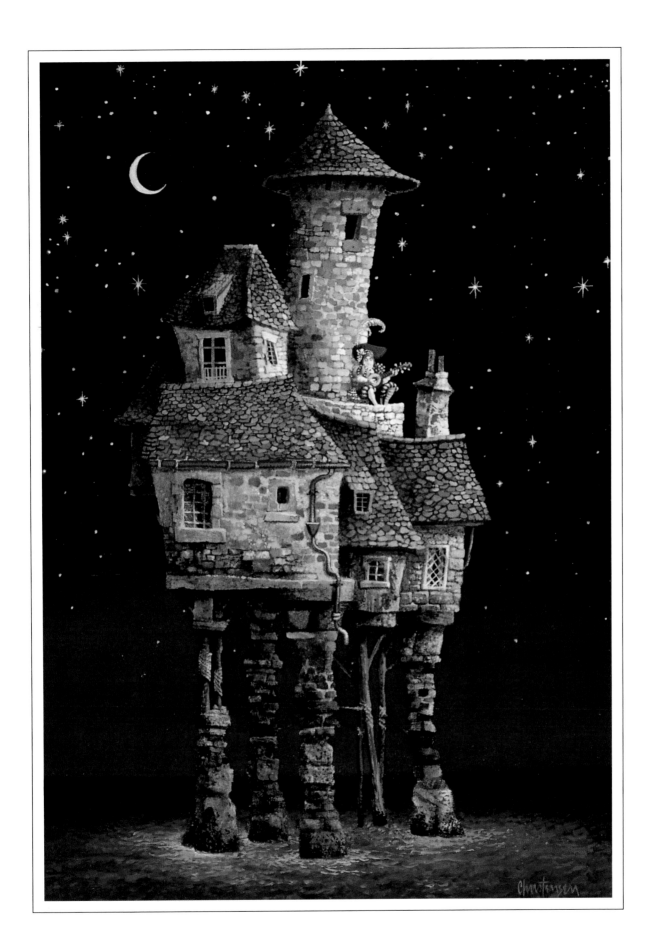

CAVE PISCEM

This significantly dressed gentleman must think his multiple layers of ostentatious clothes will make him less vulnerable. The "security" fish adds the extra layer of protection that he is seeking. The Latin warns: "Beware of the Fish."

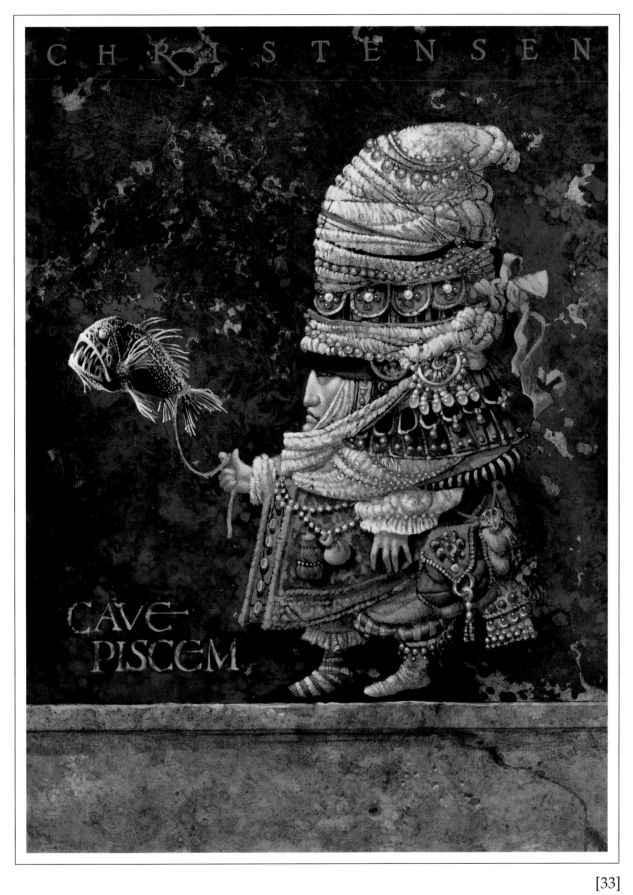

CHRISTENSEN

CAVE
PISCEM

[33]

A LAWYER MORE THAN ADEQUATELY ATTIRED IN FINE PRINT

In a world of black and white, this attorney is more comfortable in the gray area. As he studies a grain of truth, his assistant provides just enough rope for his clients to hang themselves. The scruffy stuffed owl is sewn onto his jacket for the impression of wisdom, he displays an adequate supply of loopholes on his jacket and he has a mason jar full of apple peels. (A quart of a. peels...get it?) Does he remind you of a lawyer you know?

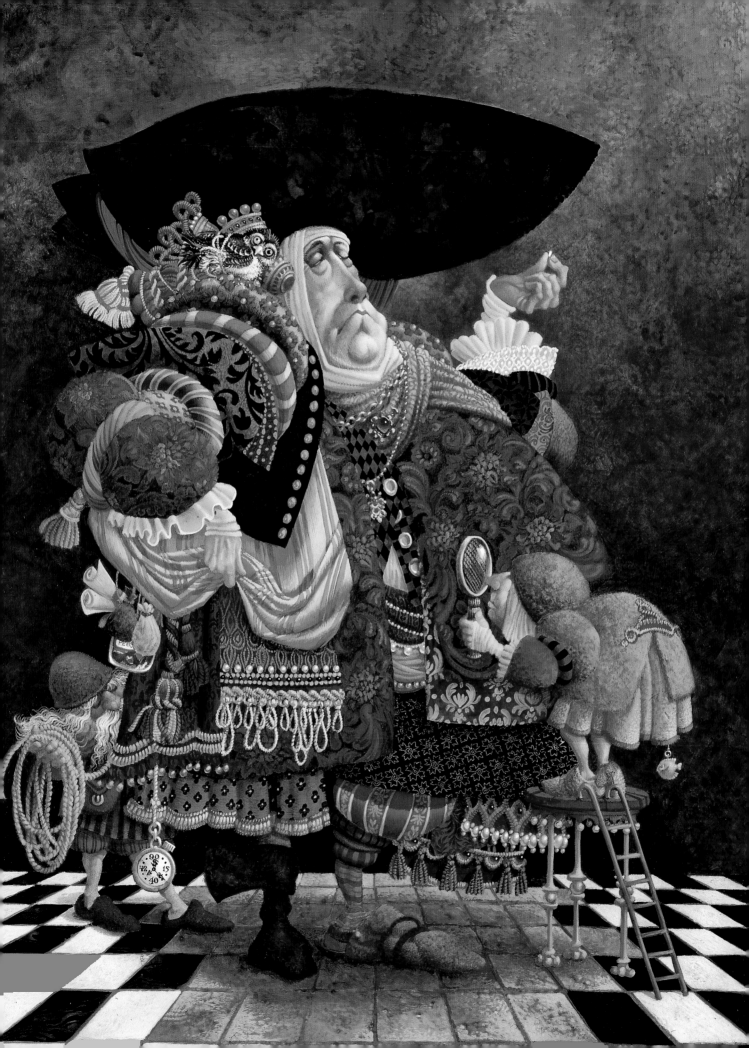

SHARING OUR LIGHT

Our talents grow when we share them and there is an endless variety of talents we have to offer each other. In the painting, people share the flame of their lamps and thereby brighten other's lives. A mother nurtures her daughter, the older woman shares her worldly advice with a maiden, and a younger man helps his elder. The sweethearts are so connected that they share a single lamp. The painting becomes more illuminated toward the top as the compassion, empathy and caring talents of many people are used to "brighten up the room." Finished here, my hunchback, "everyman" character, exits to share his light with someone outside the frame.

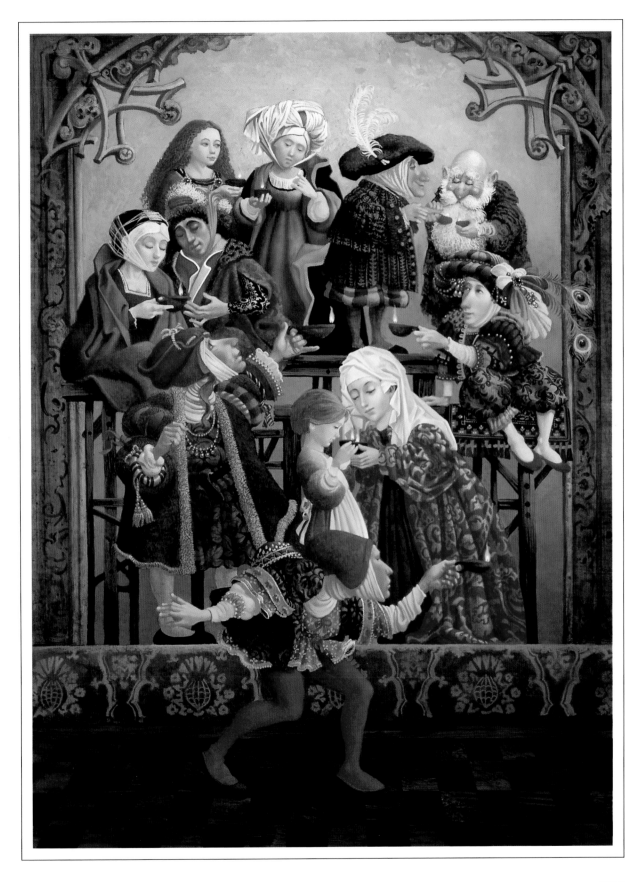

PRINCESS IN THE TOWER

Princess in the Tower evokes memories of many European fairy tales, but it's not any particular story. Why not make it the illustration for a fairy tale that *you* conjure up?

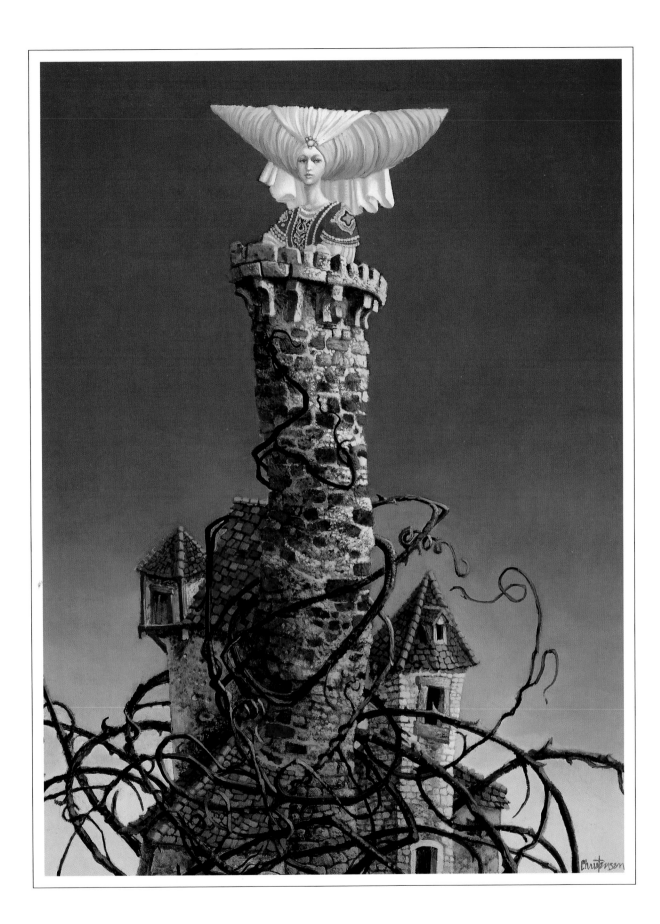

FOREST FISHERMAN

This was my first commissioned fantasy painting. The neighbor who commissioned it stopped by every couple of days to see how it was going. One day, toward the end of the painting, he said, "Boy, you've got everything in there but his lunch." So the next time he came over, there was a jelly sandwich on a chain around the character's neck.

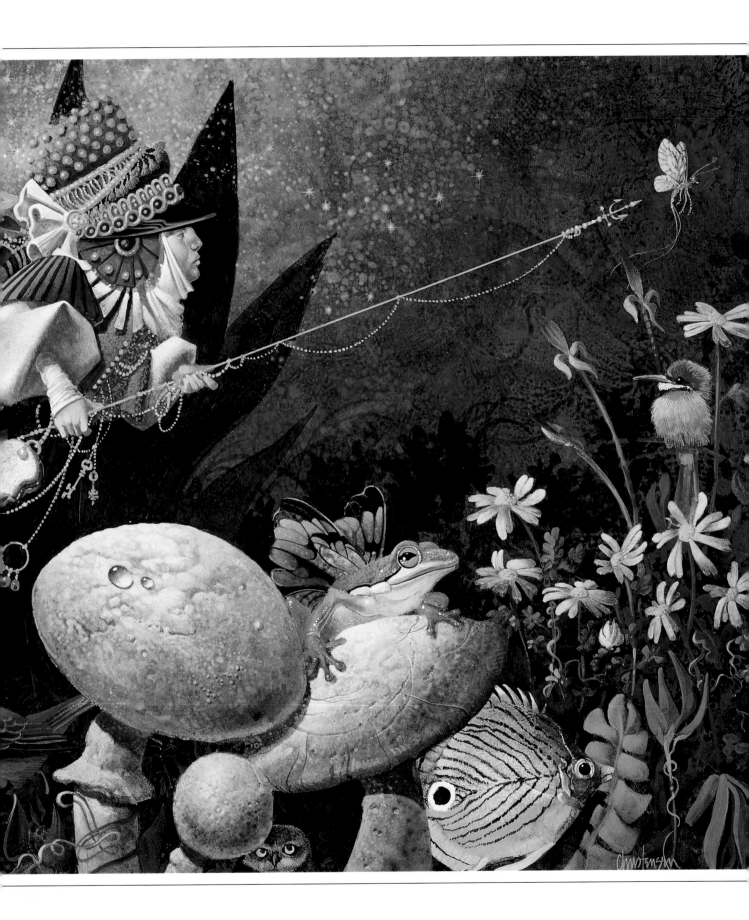

ONCE UPON A TIME

A magical storyteller in the woods tells fables to the characters who are usually *in* those fables. I've made up some characters, but I've also drawn some from literature and art. What I wanted to get across is the idea that there are hundreds of stories in this picture…more than I know. The knight refers to Edward Burne-Jones' paintings. The woman next to the knight was inspired by *The Lady of Shalott*, a painting by William Waterhouse, and the faeries are from Shakespeare's *A Midsummer Night's Dream*. The guy holding a key, with the bushy white eyebrows, is Ian Ballantine, an early fan who introduced me to Dave Usher at The Greenwich Workshop.

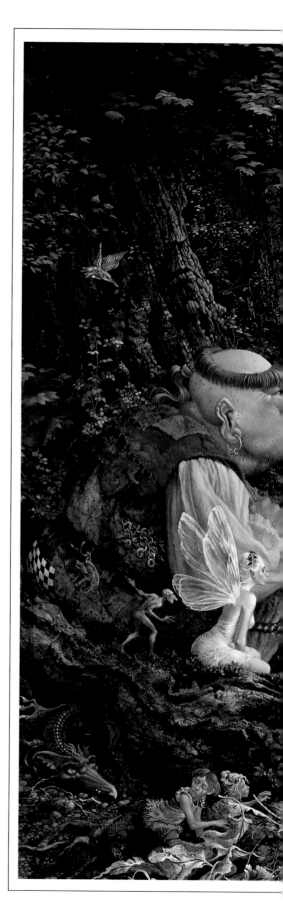

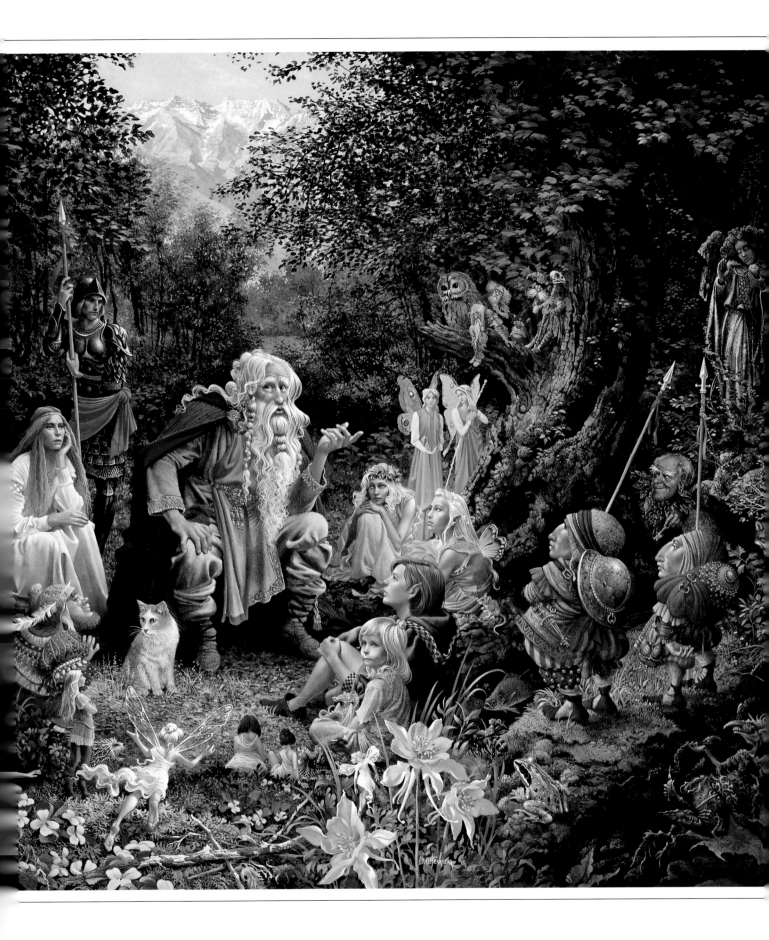

TETE À TETE

Head to head, these two young ladies are having an "intimate little talk." But what about the birds? The birds are inspired by Northern Renaissance and Medieval paintings that often used birds on the heads of their subjects to portray the people as vapid and foolish. Perhaps these ladies are engaged in bird-brained gossip.

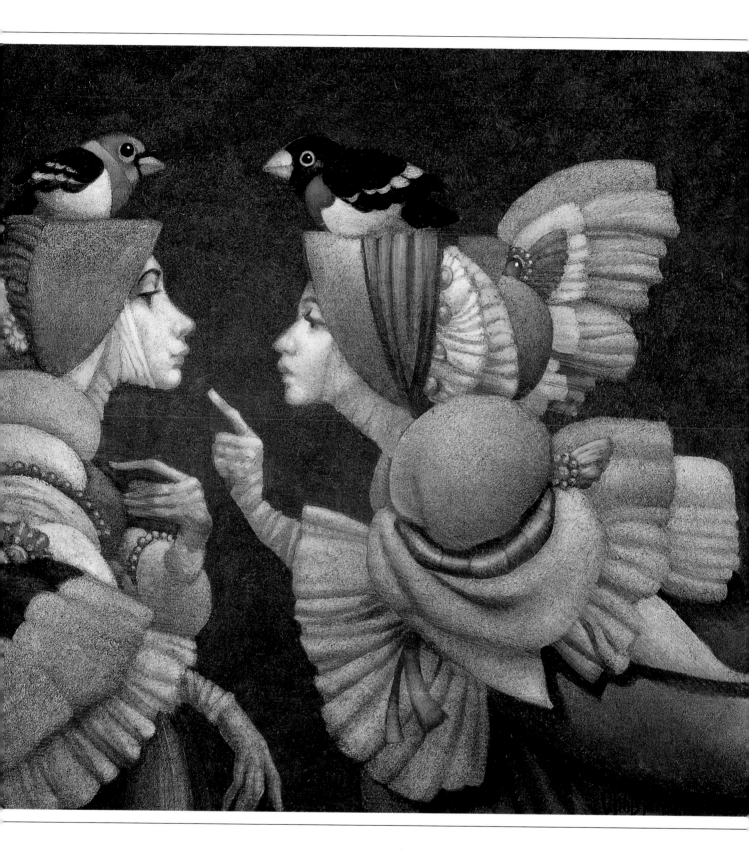

WAITING FOR OWL

Inspired by the Edward Lear poem, *The Owl and the Pussy Cat*, this little Persian cat is longing for her paramour. The bird looks on as this very lovesick suitor patiently waits for the return of the owl.

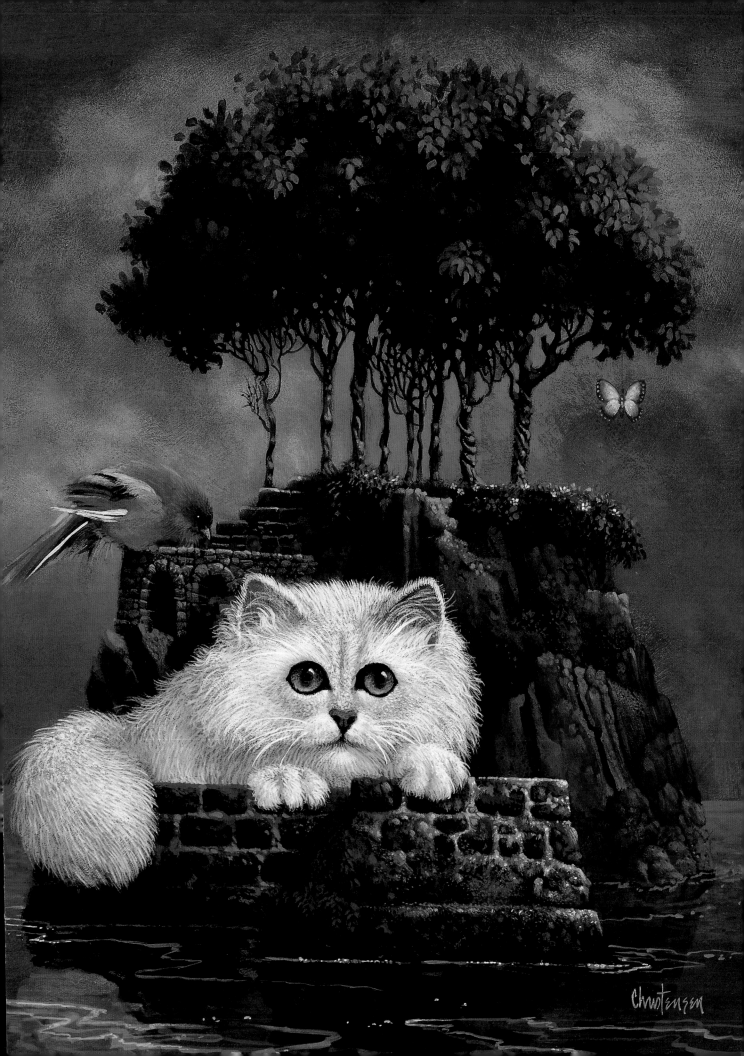

THE LAST "E" TICKET RIDE

When the original Disneyland first opened, they sold ticket books with tickets labeled "A" through "E". The "A" tickets were for small rides and the "E" tickets were for the best and the biggest rides.

Everyone recognizes the attendant in this interpretation of the last "E" ticket ride. The bare woman in the boat has given up all her layers of defense and pretense, and appears prepared for whatever comes next. The shrouded character isn't aware; he is being acted *on* and is completely passive and seemingly indifferent to his situation. The "everyman" hunchback in the boat is a self-portrait-with-sketchbook prepared to record the events as they unfold and experience the events to the fullest. I sometimes like to spoof on the formal pomposity of Latin. The sign says "Please keep your hands and feet inside the boat."

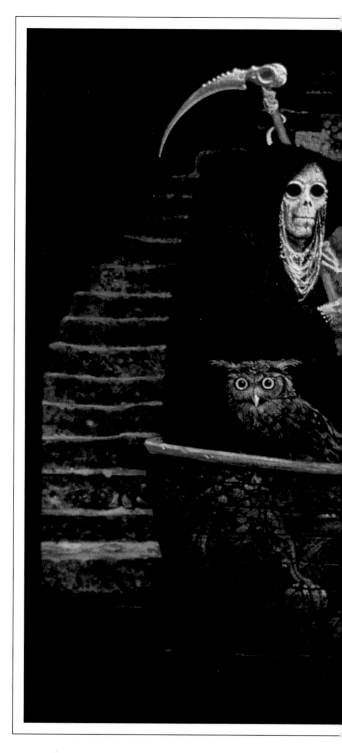

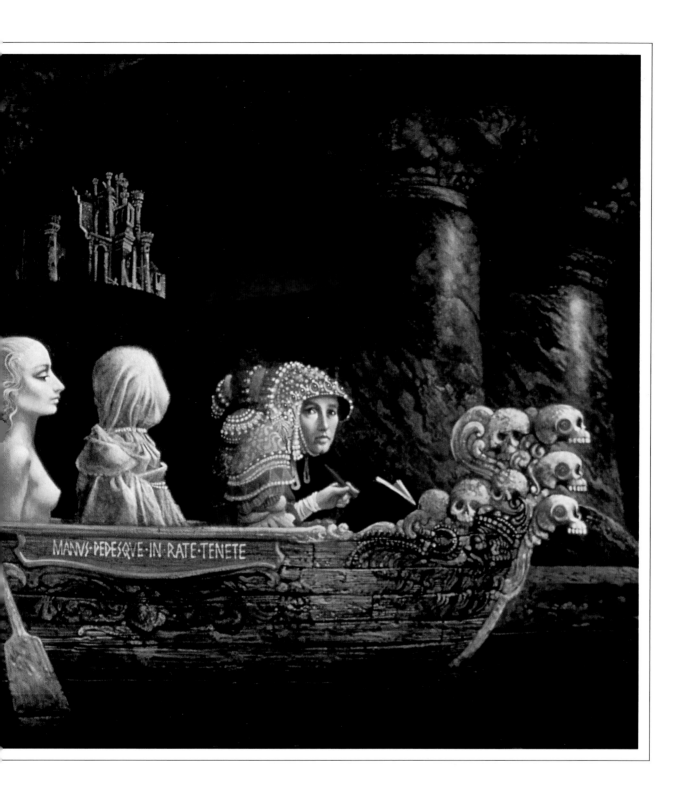

THE ANGEL
OF JUDGMENT

This pensive angel is gathering strength, waiting and listening for the call to pick up the sword to do God's work. Doing hard and unpleasant things for the greater good takes reflection for humans as well.

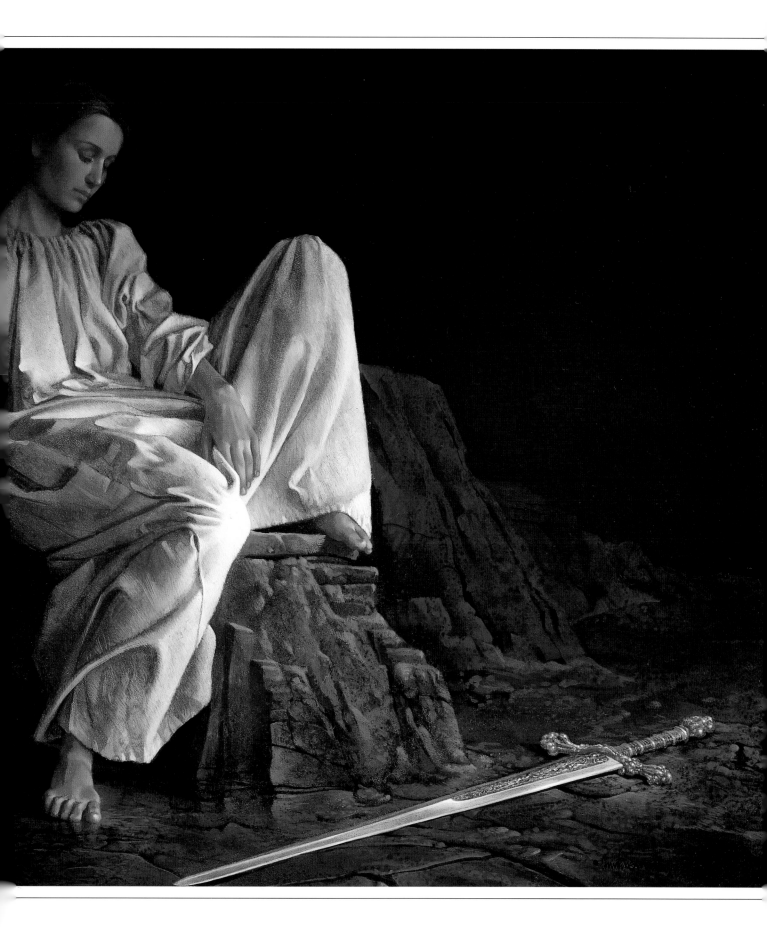

PLATFORM SHOES

Platform Shoes asks the question—does height equal importance? Is it the height of the shoes or the finery of the clothing that defines this gentleman's status?

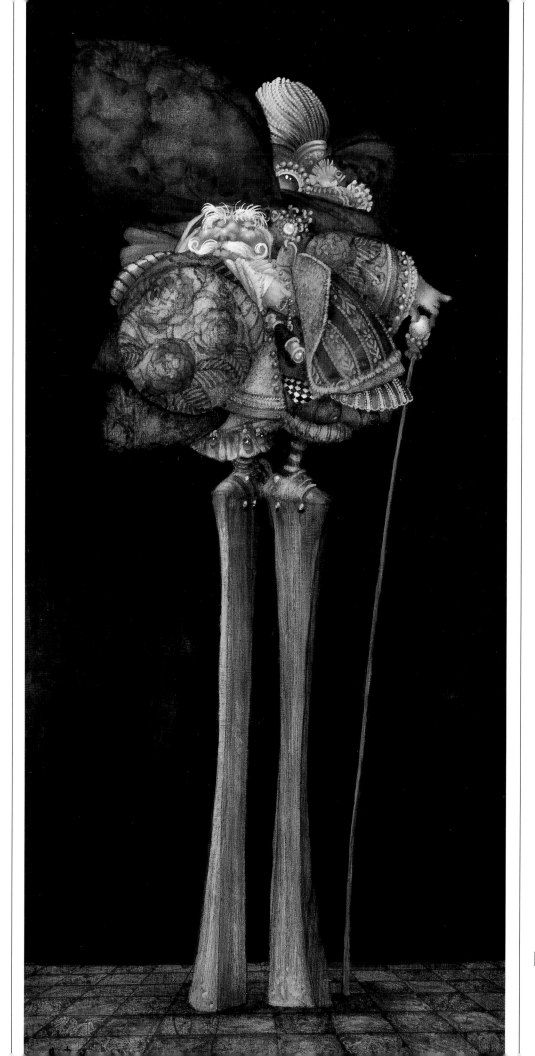

[53]

SCATOPHAGOI

Scatophages are the little fish that follow larger fish in order to feed off their excrement. The larger figure is as caught up in his persona as his followers. The Latin inscription says, "All truth resides in my bowels." The scatophages trail behind, waiting for the big guy to pass a pearl.

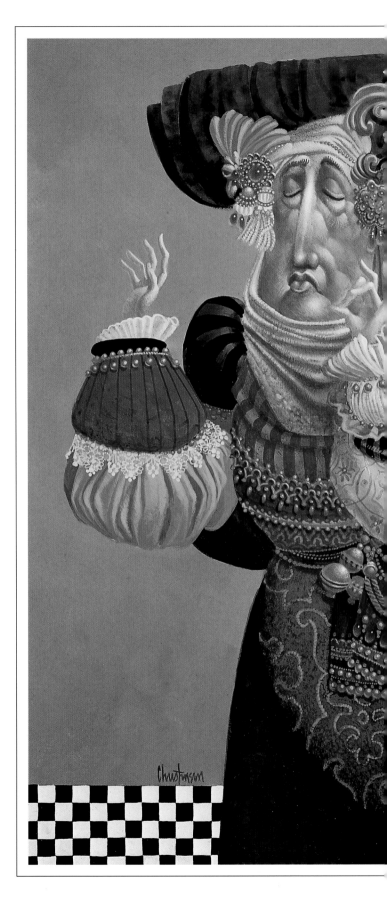

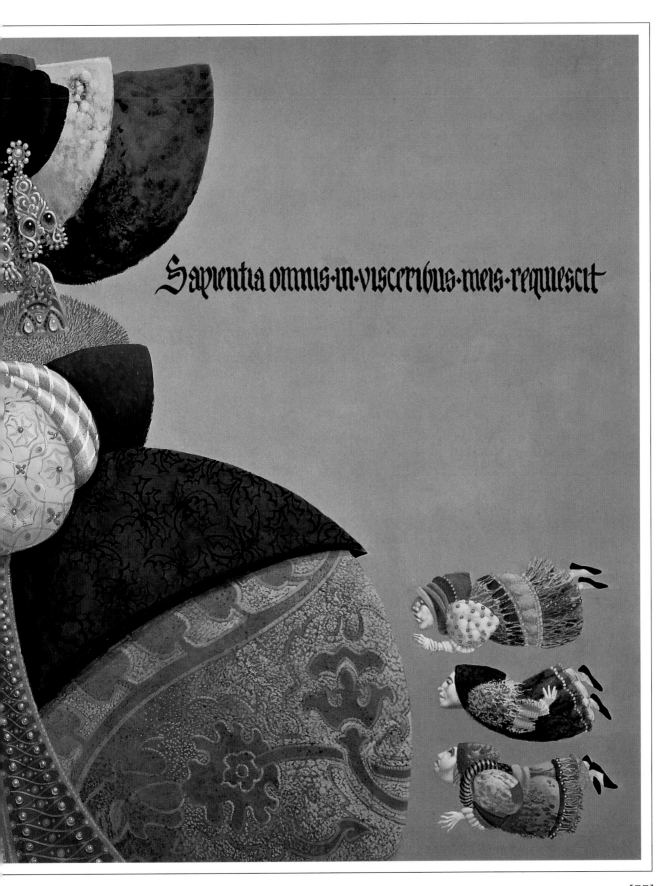

Sapientia omnis · in · visceribus · meis · requiescit

THE BURDEN OF THE RESPONSIBLE MAN

Did you ever feel the weight of the world on your shoulders? When I painted *The Burden of the Responsible Man* I felt overwhelmed by how much everybody expected from me. I felt as if life was taking everything I had and not giving much back, just dangling a carrot to keep me going. Even this man's pet, a hedgehog, needs to be fed and taken for walks, but is too prickly to offer warm "cuddlies" in return. But the man's a responsible person, and so he keeps plodding along. That's the point. I just kept plodding on, too, and things got better. I discovered that my burdens were really blessings and challenges necessary for my growth.

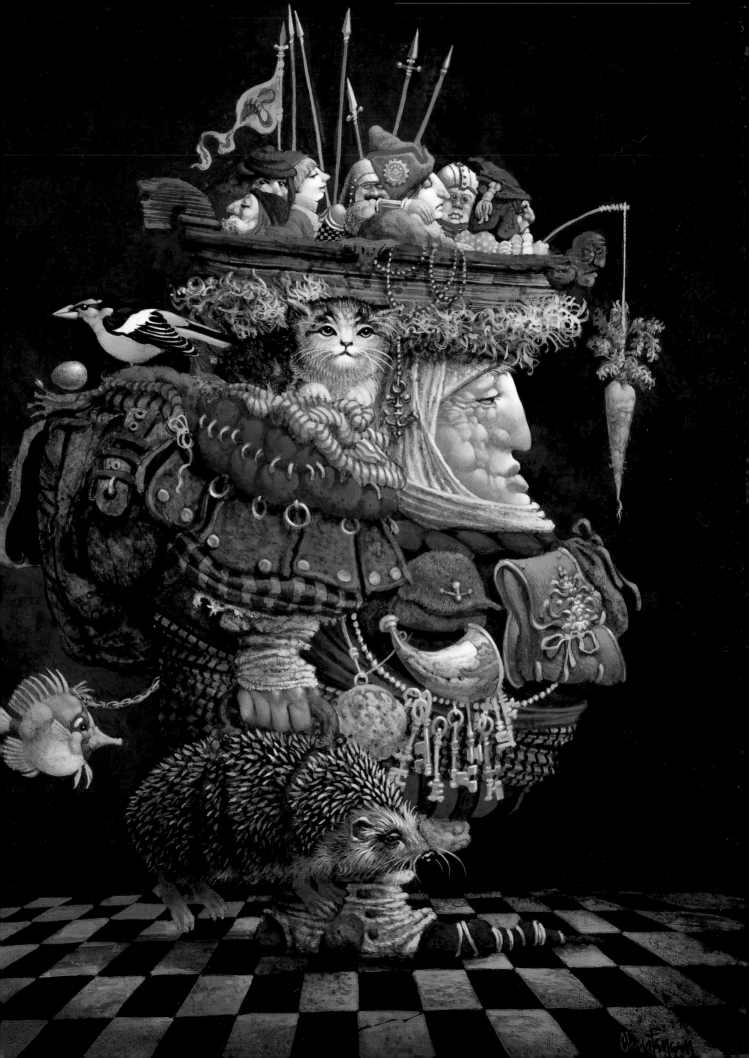

THE RESPONSIBLE WOMAN

This is a sequel to *The Burden of the Responsible Man*, however, this isn't called The Burden of the Responsible Woman. When I asked my wife, Carole, about the things that burden her down, she gave me a funny look and said, "I don't have time to be burdened." What you have here is "woman as spiritual leader." She has a candle, which is my way of showing that she is carrying the torch, or leading the way. (Notice that she is even prepared with spare candles.) She also has a many-handed clock and there is a compass, which I put in at the last minute, because today's woman really has to find her direction. I am in awe how many roles and tasks my wife and the women around me share. Keep it up ladies!

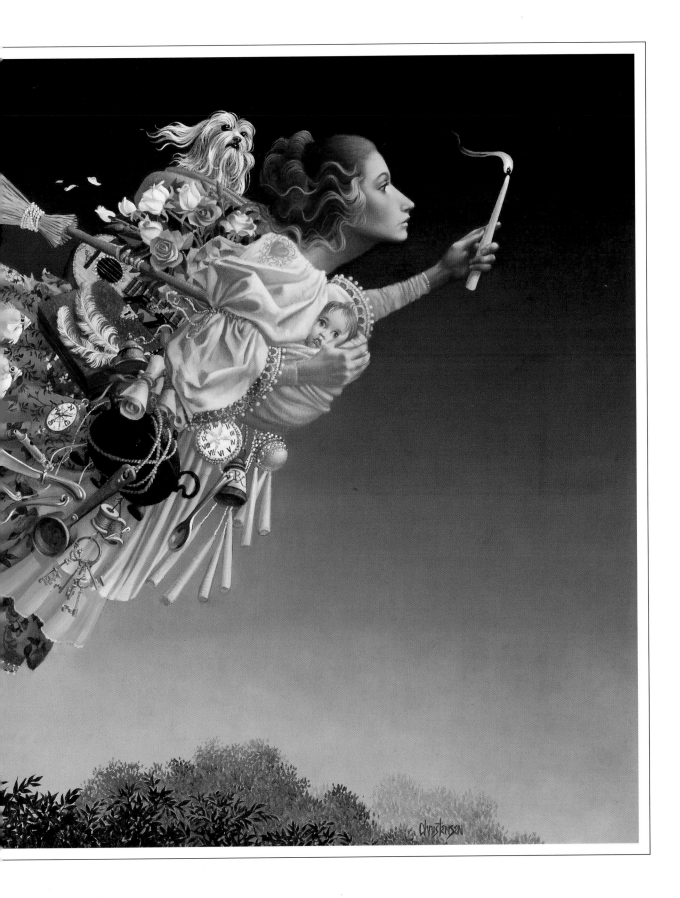

ALL THE WORLD'S A STAGE

When the Utah Shakespearean Festival invited me to do a painting celebrating their 40th anniversary in 2001, I decided to represent all of the thirty-eight plays of Shakespeare's canon in a single image. I gathered more than fifty dramatus personae—some are the "real" characters and others are the actors in rehearsal. Still others, inspired by *The Tempest* and *A Midsummer Night's Dream*, are not quite human. Many of the historically based figures, Henry IV, V, VI and Richard II, for example, are closely modeled on contemporary likenesses.

The painting has some of the magic of theatre—where does the drama leave off and the magic begin—and of Shakespeare in particular: what is reality and what is illusion? The setting is, naturally, the Old Globe Theatre, which I've embellished. The Latin behind the Bard, who stands in the middle, says: All the World's A Stage.

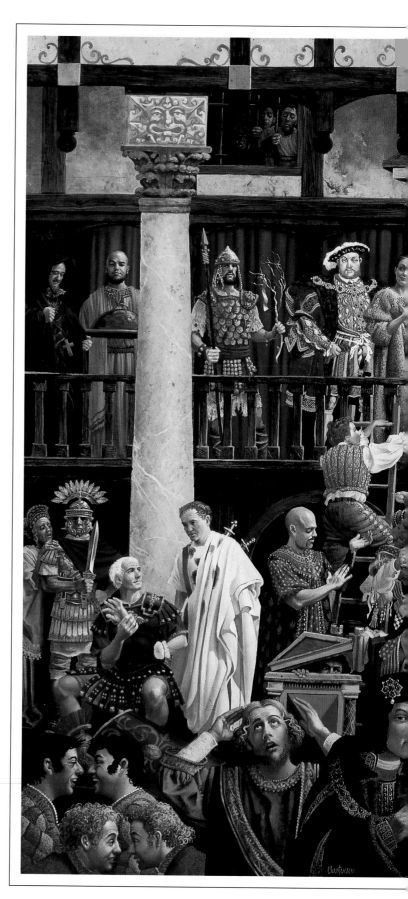

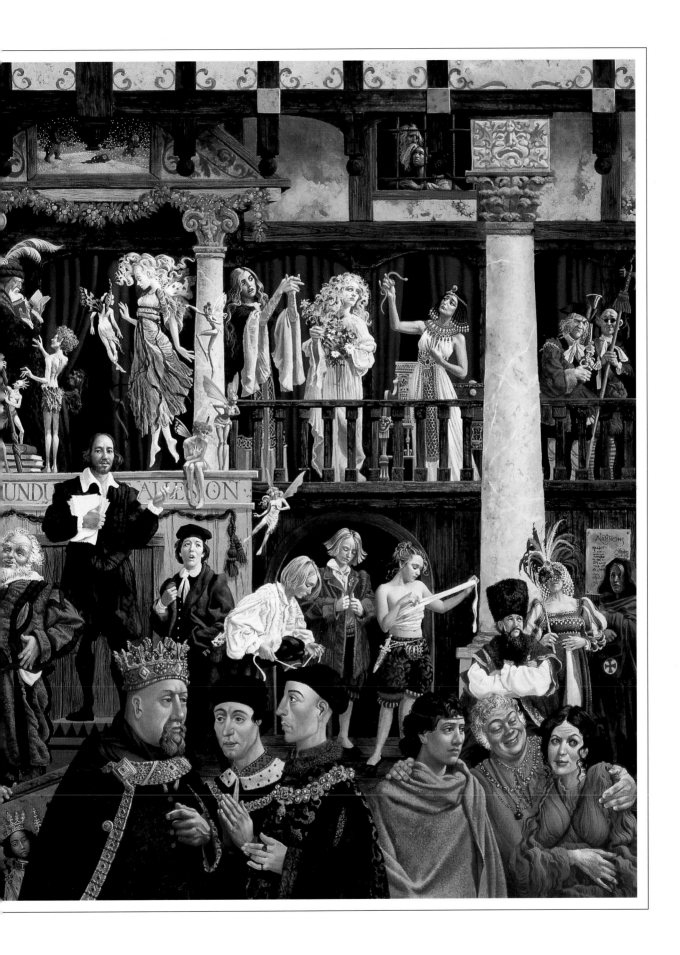

QUISQUILIA

Quisquilia is a Latin word which quite literally means "the junk that gathers at the bottom." You know, the stuff in the bottom of your sink after you finish rinsing the dinner plates from Thanksgiving dinner. This is a very large, textured painting that offers a loose collection of unpleasant characters.

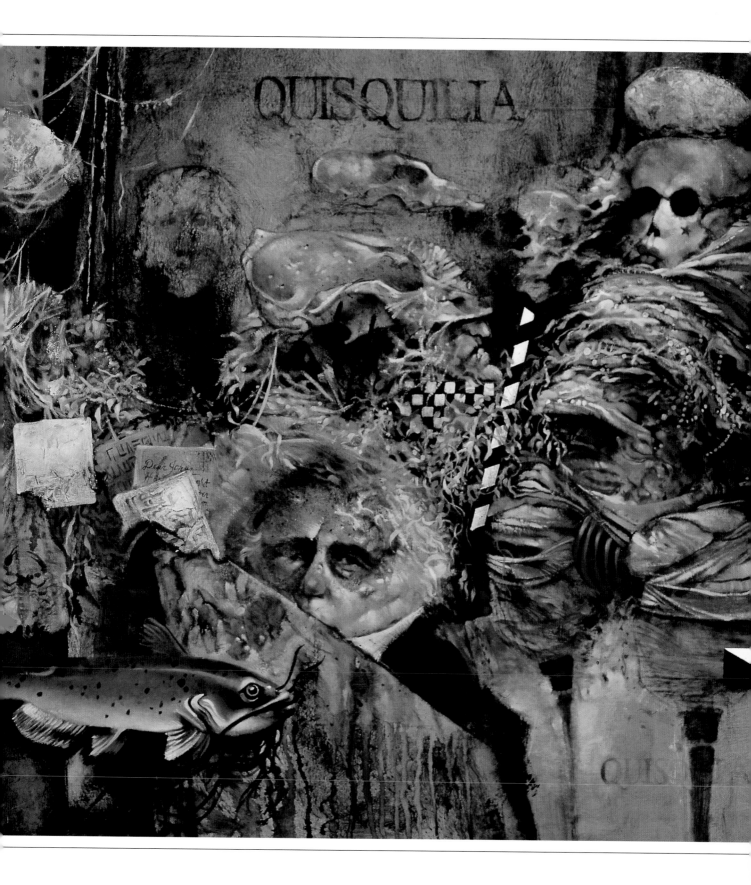

TEA TIME

I like the idea of exploring the theme of conversation and communication among civilized beings. This painting is part of a series along those lines. I like the crow, but I don't know what he's doing there. He certainly doesn't look like he's paying attention to the conversation.

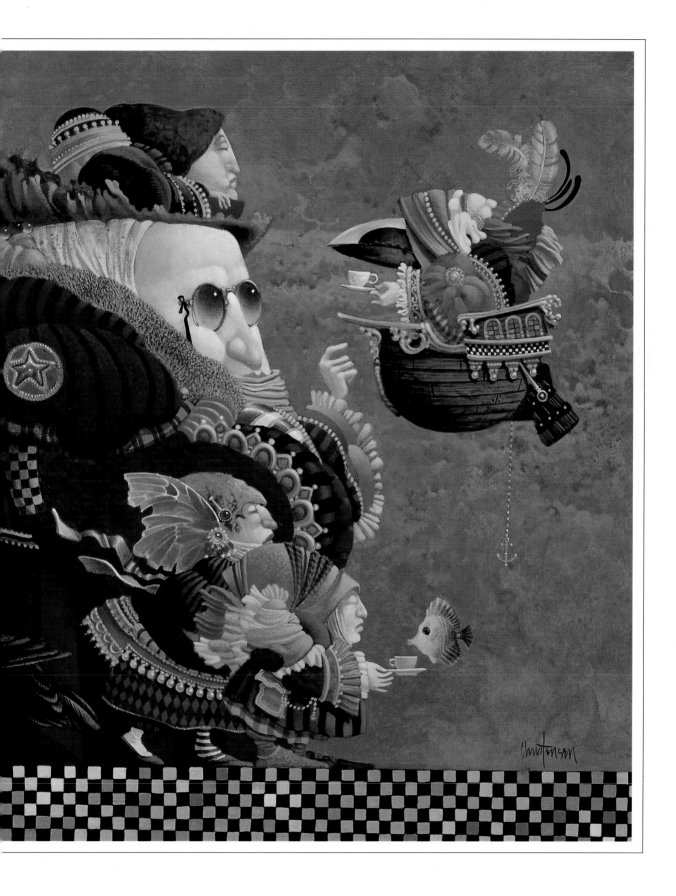

THE OATH

I started this painting with a historical perspective, starting with the Oath of Hippocrates, a pledge doctors have honored for nearly 2,400 years. Medicine has taken strange and interesting directions that Hippocrates would never have imagined. Some archaic ideas and treatments have fallen by the wayside and would surely elicit a chuckle—or shudder—from modern physicians and their patients. On the other hand, some formerly abandoned treatments have been revived with surprising new applications. Leeches, for example, are no longer used to remedy bad humors or gout, but they have been used recently to improve the circulation of burn victims. I'm also sure Hippocrates could never have foreseen what upholding the Oath means for doctors now: the omnipresent beeper, the mountains of paperwork, the overwhelming choices in pharmacopoeia. It all makes me glad I'm on the other end of the stethoscope!

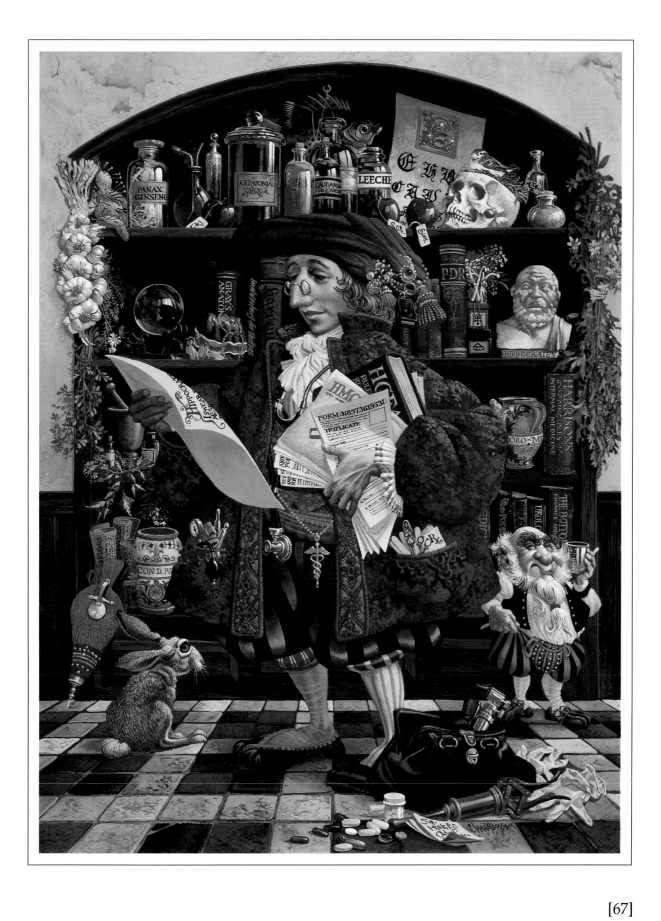

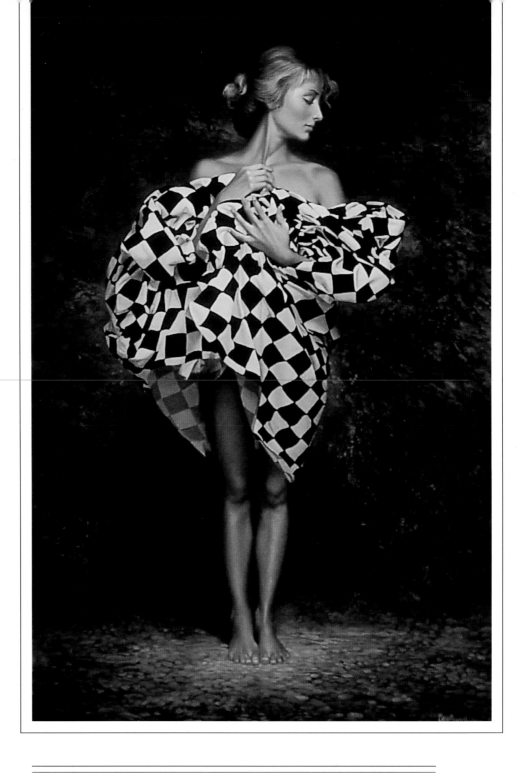

THE CHECKERBOARD SHEET #1

I love to paint women and occasionally I allow myself the guilty pleasure of painting a simple figure study. A friend of mine mailed me this checkered fabric and I couldn't resist the temptation of combining my favorite pattern with a beautiful model. Bunching the sheet loosely around her, I explored shape and color.

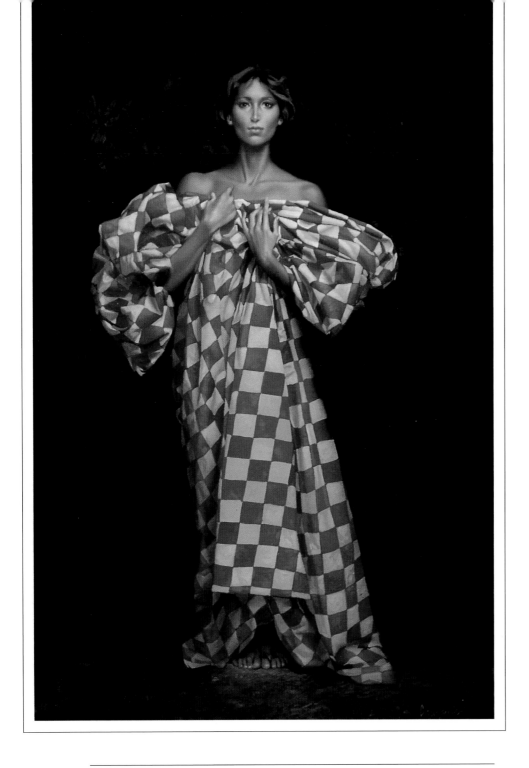

THE CHECKERBOARD SHEET #2

A variation on the beautiful-woman-with-patterned-fabric theme, the same model was painted with the checkered fabric held up and draped with a distinctive ball gown effect.

TWO MEN IN CONVERSATION ATTEMPTING TO PUT THINGS INTO PROPER PERSPECTIVE

The "perspective" in this title is both philosophical and a play on the rules of Gothic painting which pre-dated linear perspective and vanishing points. Scale was more important than perspective, so the most important figures were the largest figures in a painting.

For centuries, old men in town squares and villages have sat around and philosophized, trying to put life into perspective. Maybe they start with the members of their own community, the social strata from beggar to nobleman to scholar. Once rumor and innuendo are digested, they may chew on some of the larger issues.

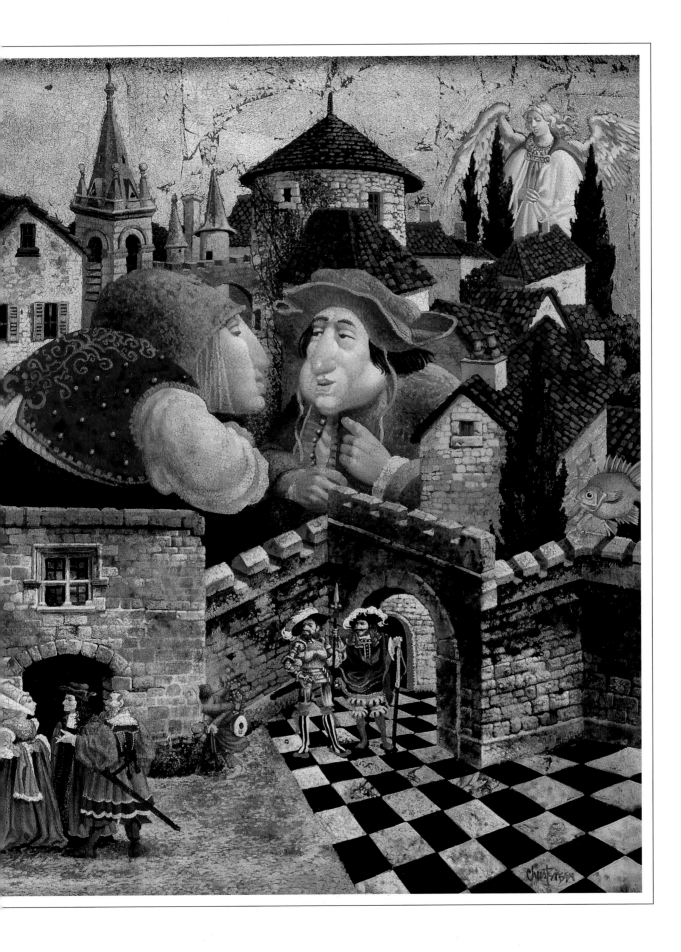

STUDY IN GOLD AND BLACK

This is a study of design elements: space, color and shape.

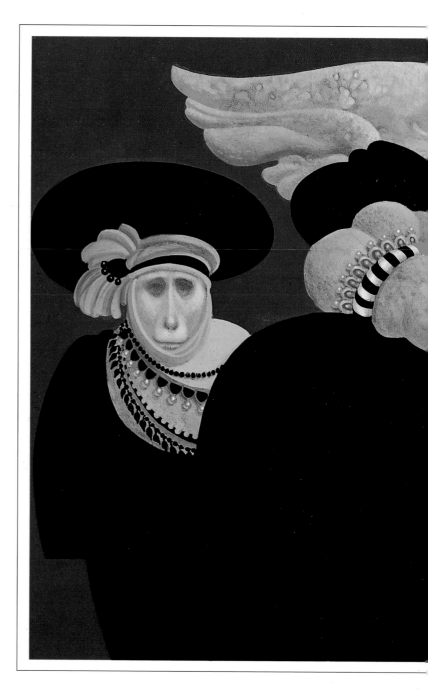

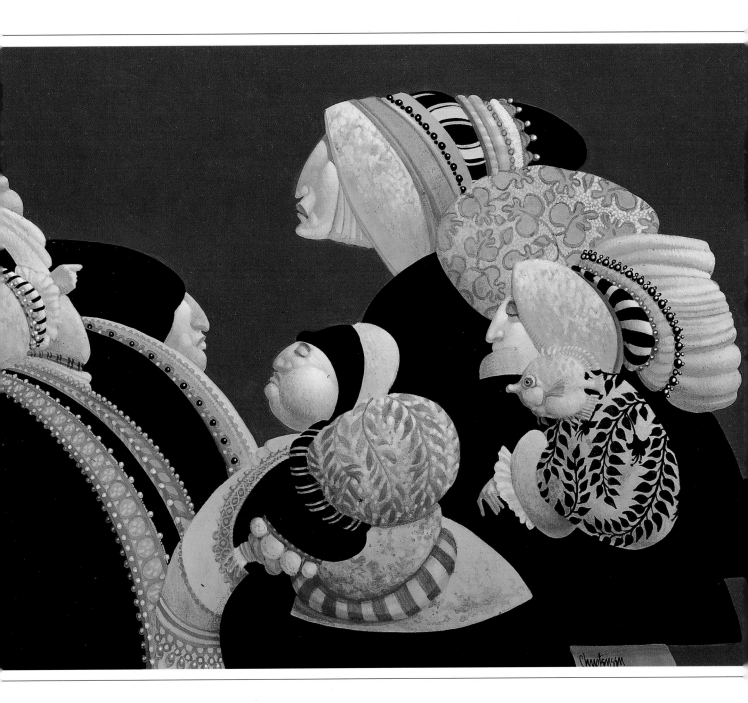

TEA, TEA, ENNUI

People-watching in cafes inspired this painting. Sometimes people have their eyes open but they're not seeing anything around them, or paying attention to each other. There's a listless melancholy floating around these two, as they begin to disappear into the background. The color leeches away from the whole tea scene. Even the magical fish melts into the neutral, blue-gray.

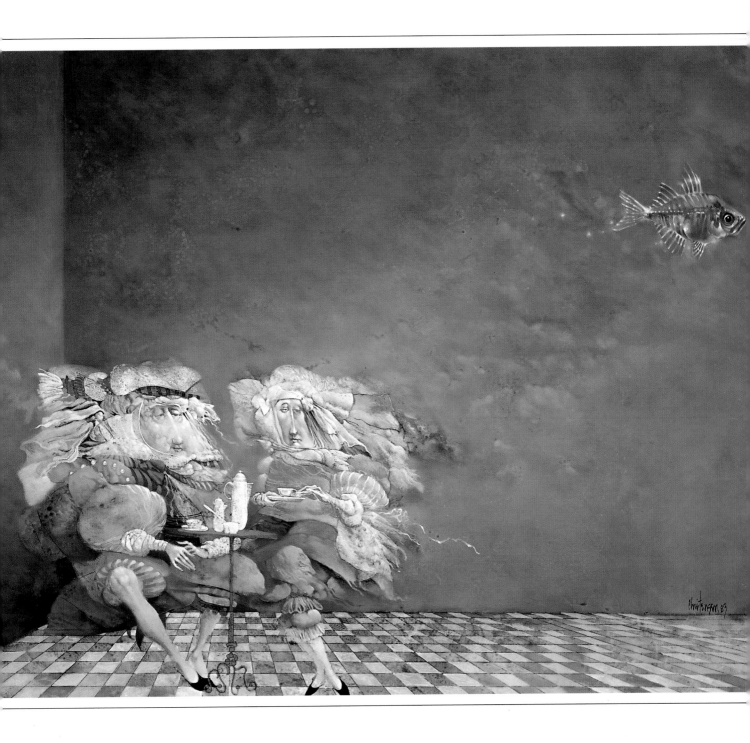

THIS IS
NOT A FISH

I was inspired by René Magritte, a 20th century Belgian painter whose surreal works, like "This is Not a Pipe," (it's a painting of a pipe) depicted ordinary objects in unexpected or implausible situations. I like a little self-referential fun, so in my painting the art professor type instructs the viewer: "this is not a fish…"

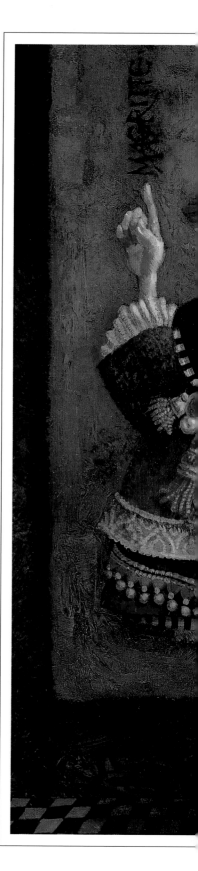

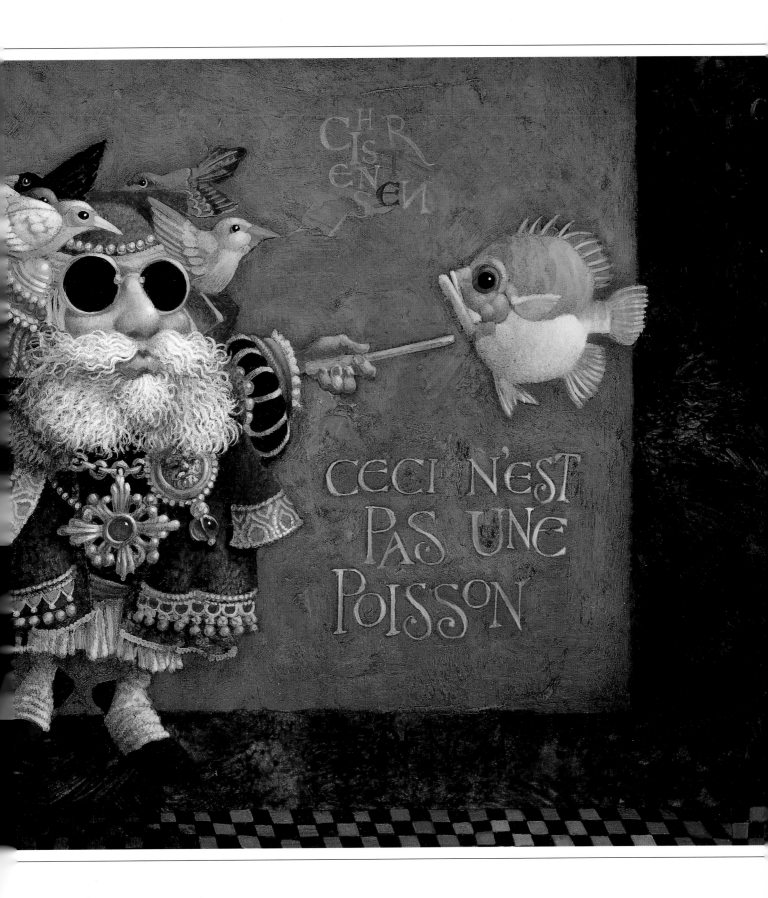

WOMAN
IN A BOX

Since I painted this, I have heard several completely opposing interpretations of this image. I love to paint things that will be defined based on the life experiences that the viewers bring to the piece. That's a truly shared art experience...a connection.

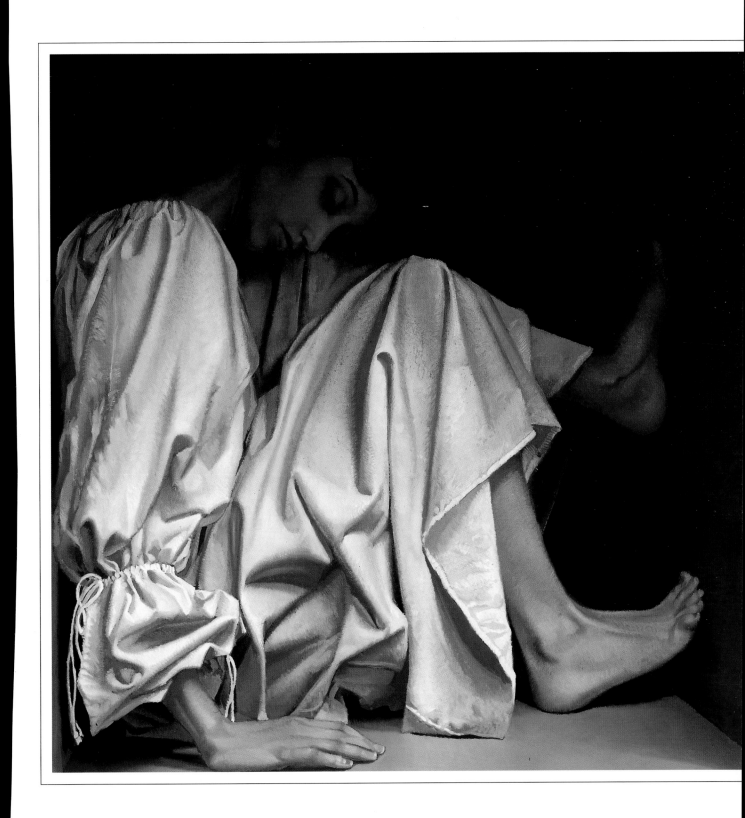

INDEX

THE ARTIST: JAMES CHRISTENSEN

Drawing upon his own observations of everyday life and inspired by the world's myths, fables and tales of the imagination, James Christensen is recognized as one of the world's foremost fantasy artists. Christensen was born in 1942 and raised in Culver City, California. He studied painting at the University of California at Los Angeles before moving to Utah and finishing his education at Brigham Young University.

James Christensen is one of the few people lucky enough to create worlds of their own and make you wish you could live in them. Christensen invites us to examine the foibles and follies of human life utilizing imaginative detail and clever humor to provide ever-challenging new perspectives.

Christensen's art is prized in collections throughout the world. His works have been included in over 100 shows in the U.S. and Europe. He has won multiple awards from the World Science Fiction Convention and the Association of Science Fiction and Fantasy Artists. He was awarded the Utah Governors Medal for Fine Arts and inducted into the *US Art* Hall of Fame.

7 66710 88205 2